Custard and Mustard

Carlos in Coney Island

Written by Maureen Sullivan Illustrated by Alison Josephs

MoJo InkWorks

MoJo InkWorks™

MoJo InkWorks is a children's press.

Text copyright © 2009 by Maureen Sullivan

Illustrations copyright © 2009 by Alison Josephs

Printed in the U.S.A.

Carlos the Dog™, Carlos Gets Around™ and Carlos the French Bulldog™ are trademarks of MoJo InkWorks.

MetroCard® Metropolitan Transportation Authority. Used with permission.

THE MERMAID PARADE® and MERMAID PARADE® are registered trademarks of Coney Island USA, Inc., Coney Island's resident not-for-profit arts organization. Please visit www.ConeyIsland.com.

For information contact:
Maureen Sullivan, MoJo InkWorks,
16 Foxglove Row, Riverhead, NY 11901-1216
Phone: 212-243-0732
www.custardmustard.com www.mojoinkworks.com

Library of Congress Control Number: 2009902826
Sullivan, Maureen. ISBN 978-0-9820381-1-6. First Edition.

For Mary Gertrude O'Loughlin and John Francis Naughten,
who cast stones from their homeland's western shore and crossed
the sea so their children could throw them back.

MNS

For Moby Focker, who gave me elbows.

AJ

The AC was straining
to keep the place cool.
We needed to get some
fresh air, hit a pool.
Out came the flip-flops,
a towel for the beach,
when Tara called
"Carlos!
Go get your leash!"

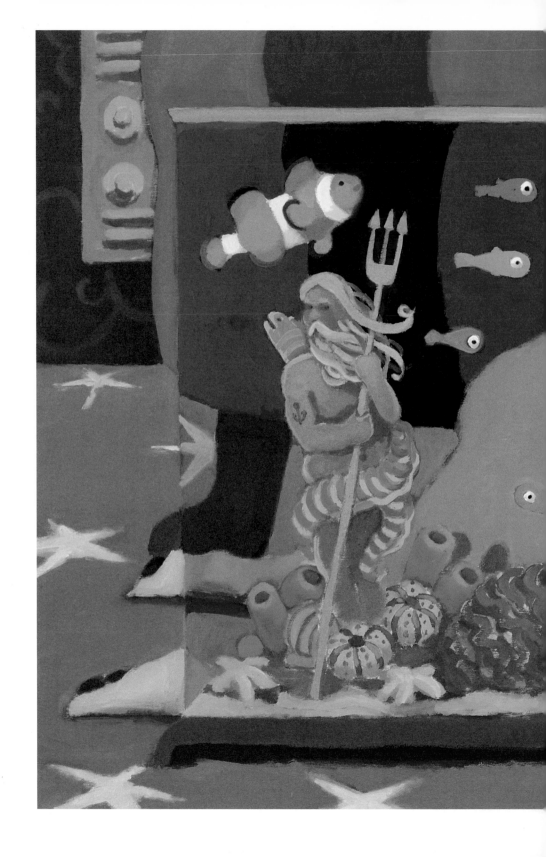

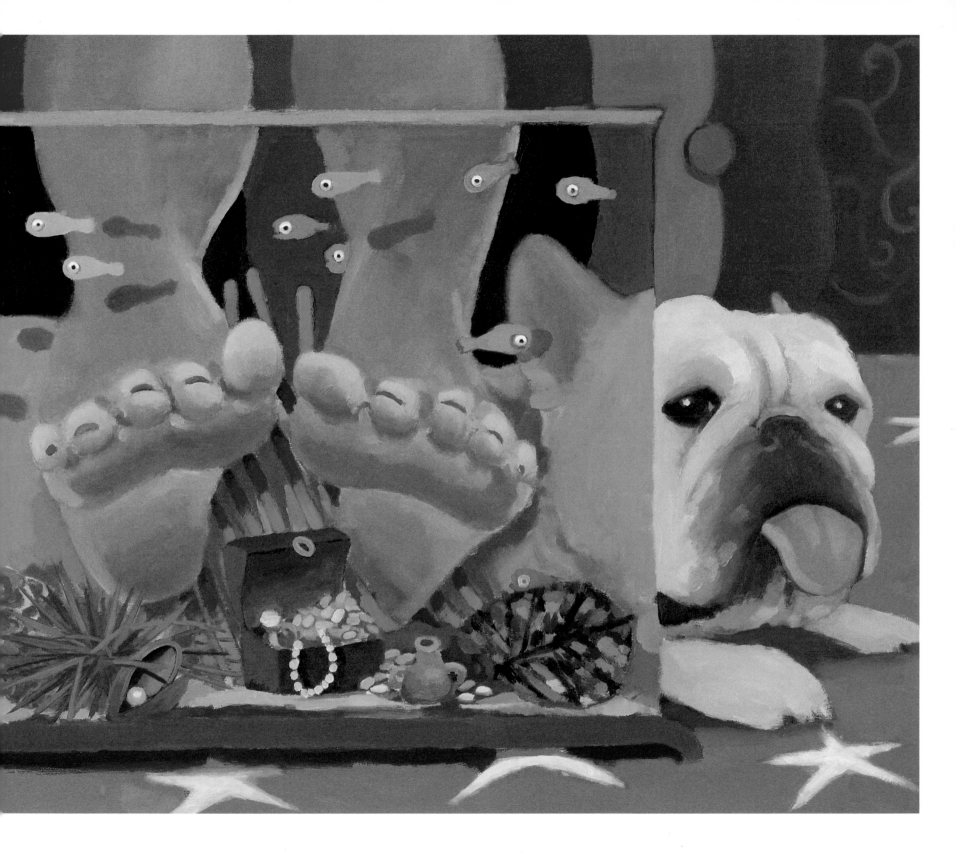

We pulled into Stillwell,
the subway's last stop.
A salty breeze smacked us,
then booms of hip-hop.
Coney Island requires
no membership card.
All the world's on the guest list
in New York's backyard.

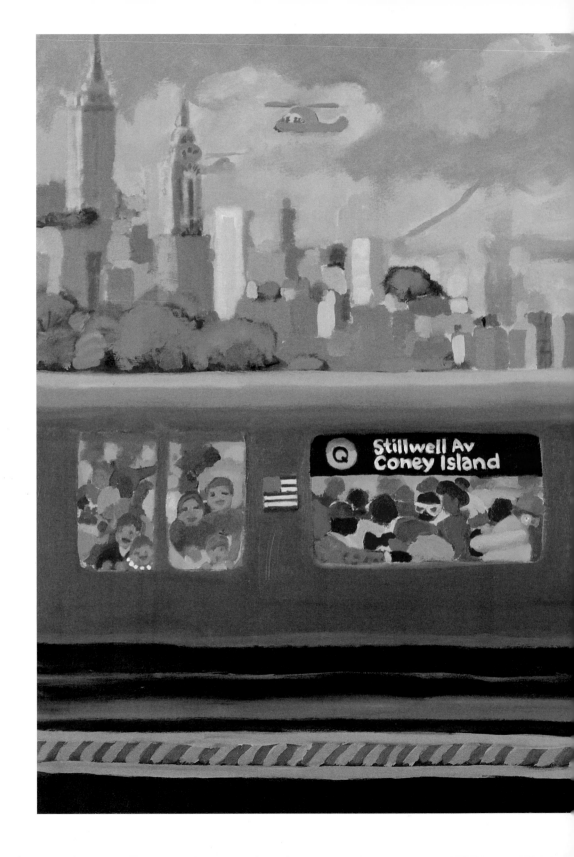

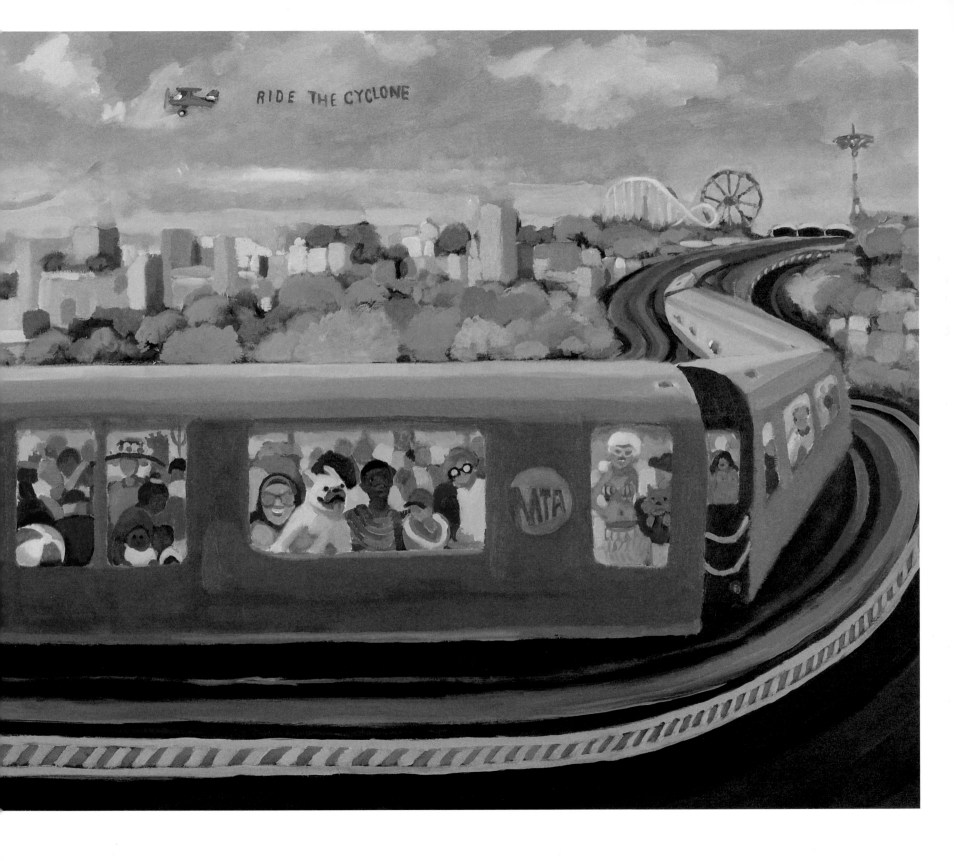

This delicate pretzel,
all lacy and white?
Don't let it fool you,
you'd better hold tight.
Your fast beating heart
could end up in your mouth,
when the car inching northward
decides to plunge south.

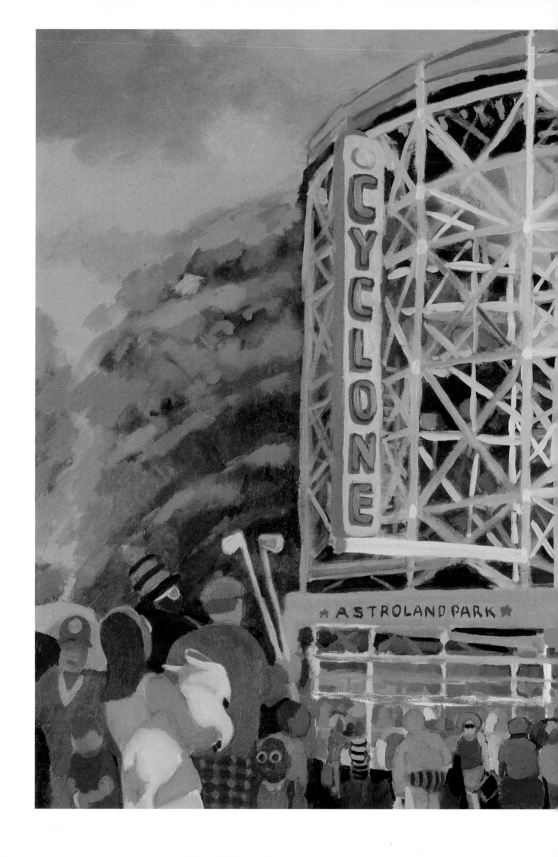

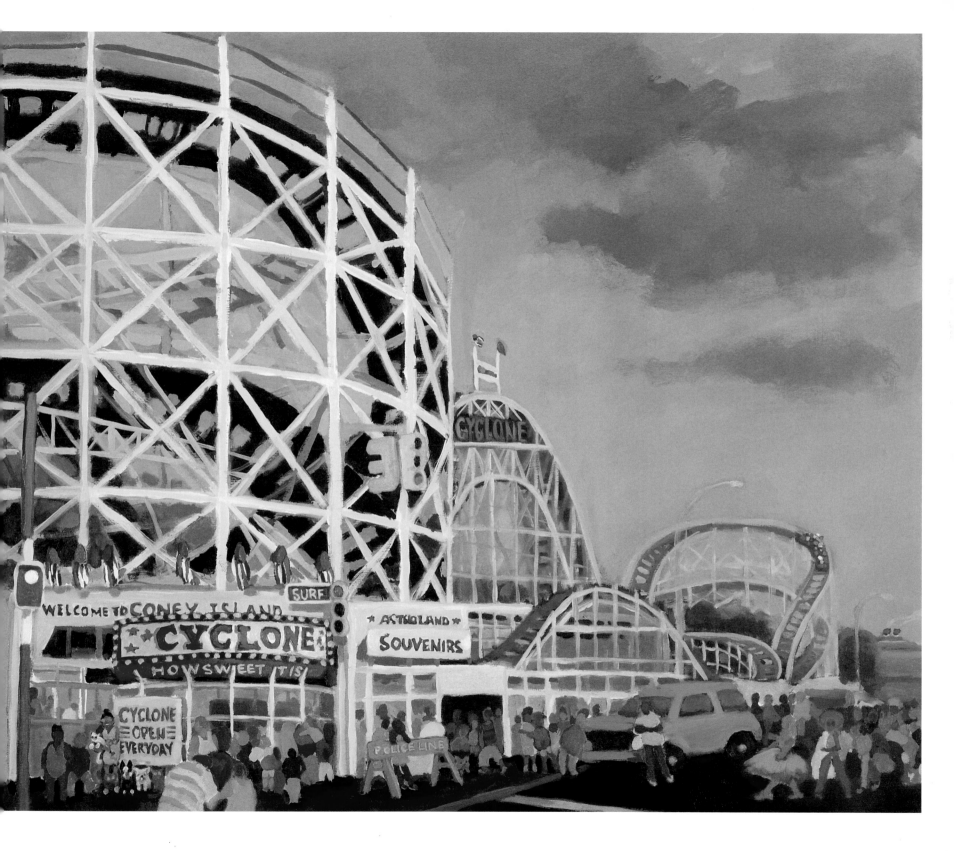

A Japanese gent
shaped like Ichabod Crane,
slid two hundred hot dogs
inside his thin frame.
Where do you put it?
I'd sure like to know.
And why don't you look
more like a sumo?

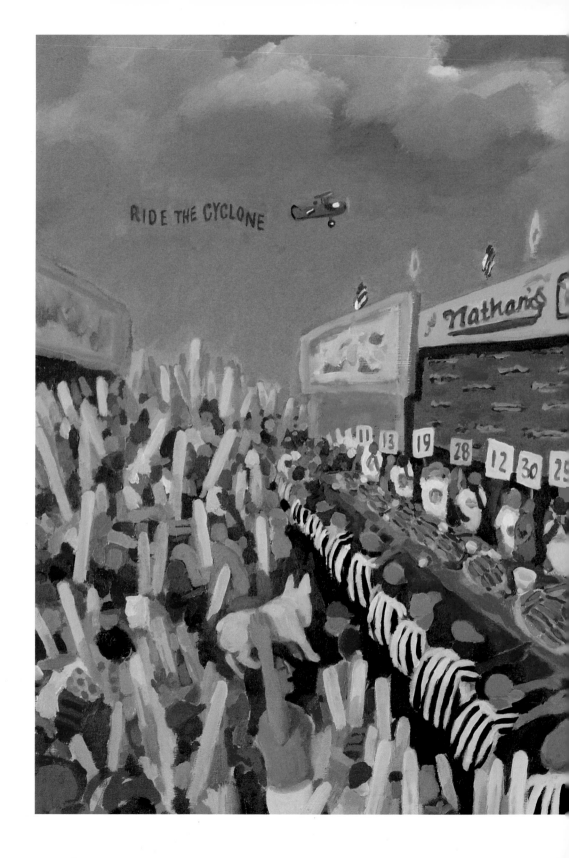

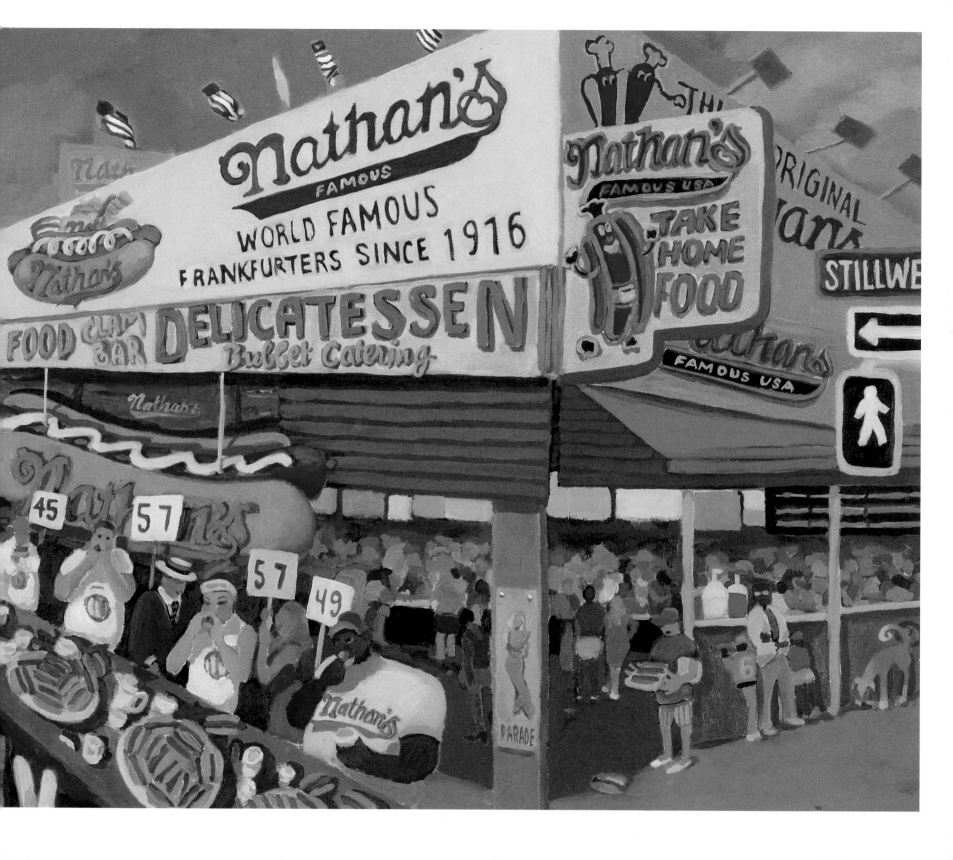

In the midst of this Gastroland
stood a park they called Astroland,
Rocket Ship, Tilt-a-Whirl,
squeals of delight.
Deno's still here
with his dark Spook-a-Rama,
where scaredy-cat grown-ups cry
"Where is my mama?"

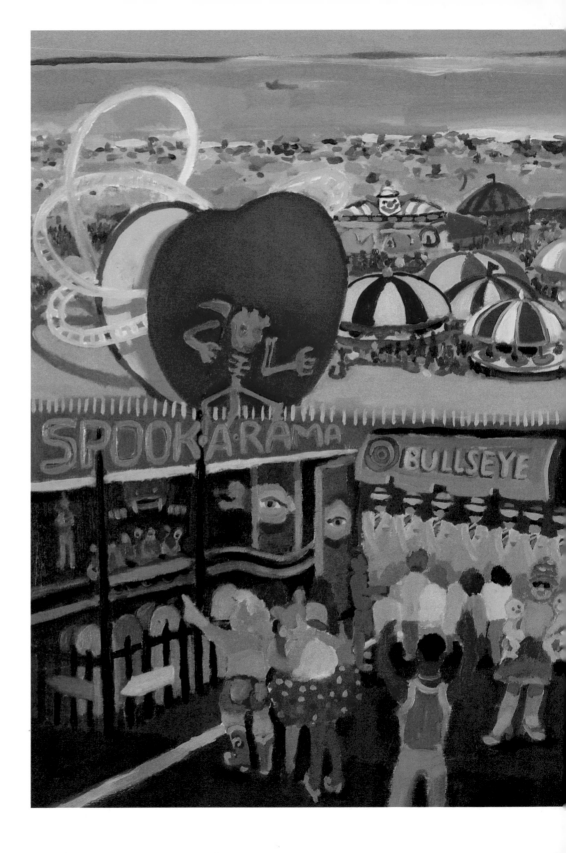

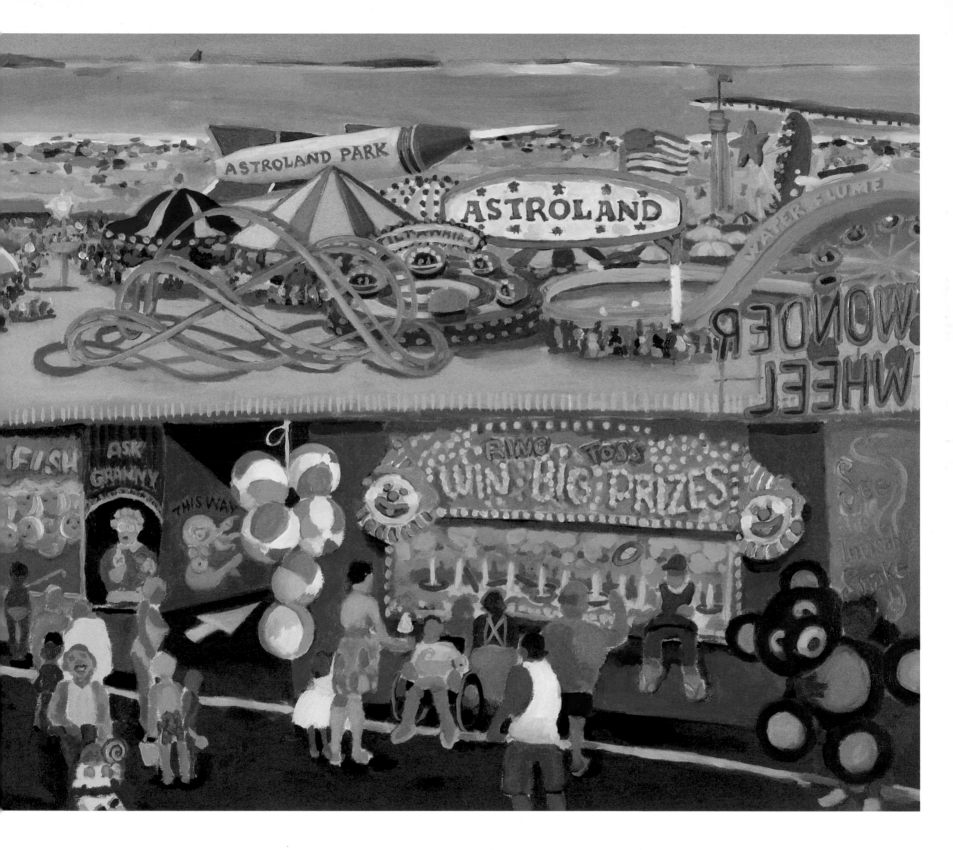

A walrus in free fall,
coral in bloom,
morays aflutter,
penguin…or groom?
Stingrays and starfish
steer clear of the shark.
Oysters clam up when
electric eels spark.

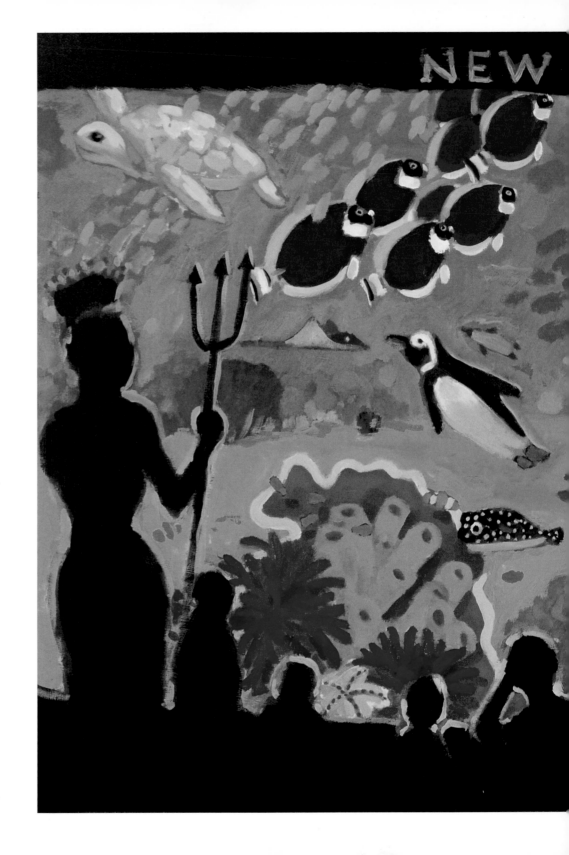

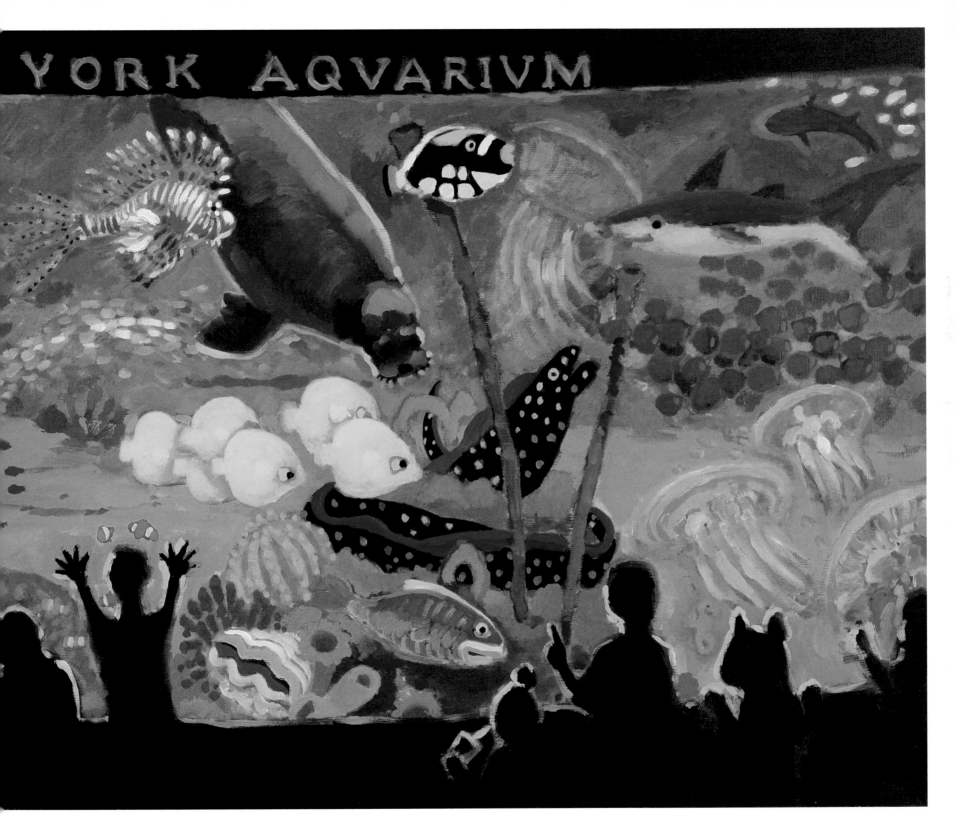

Hamburgers sizzling,
funnel cakes drizzling,
barkers who bark
while hawkers cry "Eat!"
"Custard and Mustard!
Hot corn! Pizza pie!
Papayas! Tamales!
Ain't nothin' won't fry!"

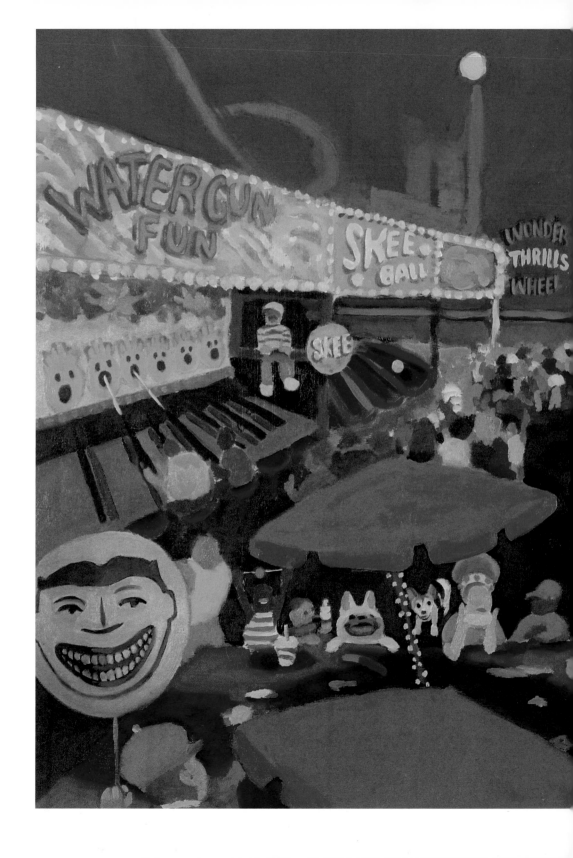

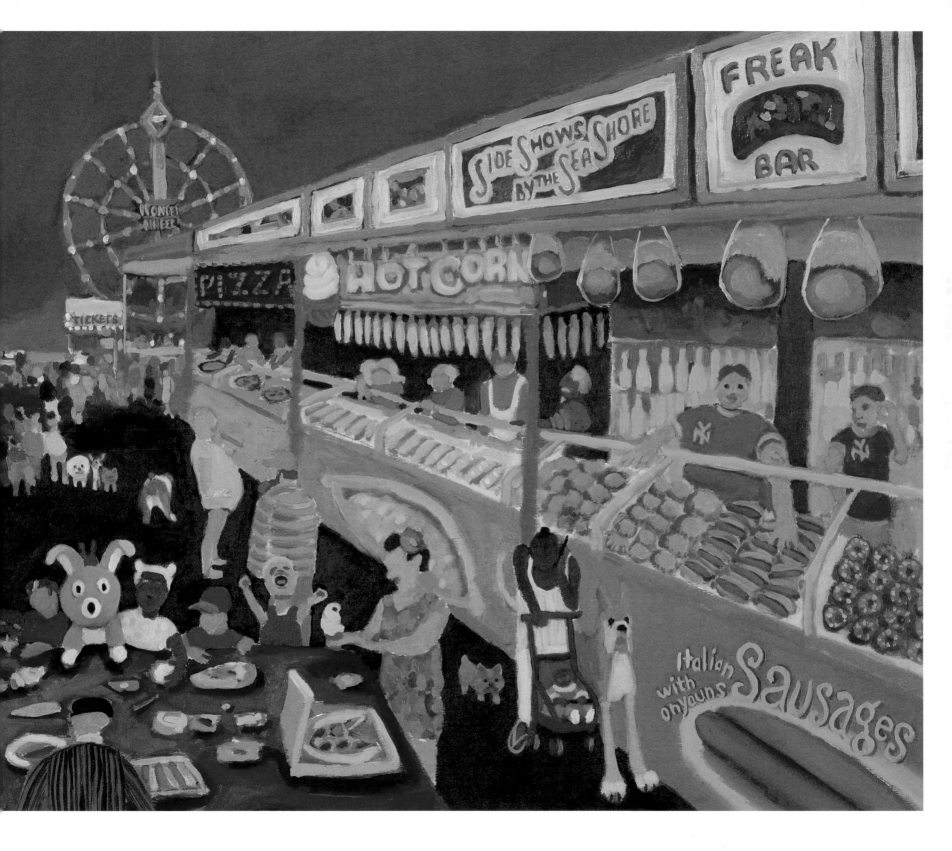

For less than a buck
you can step back in time,
see Steeplechase Park
when a ride cost a dime.
To the world's smallest lady,
I'm the world's tallest pooch.
"Get over here big boy
and give me a smooch."

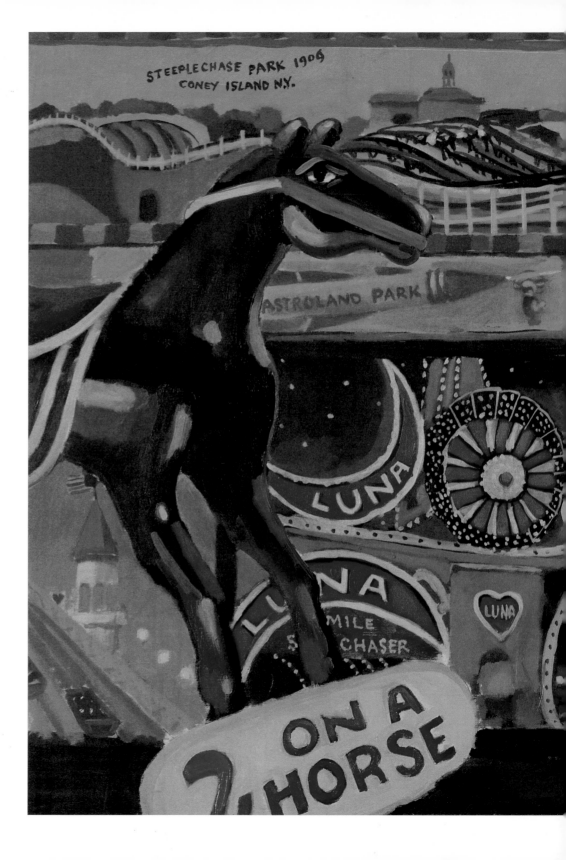

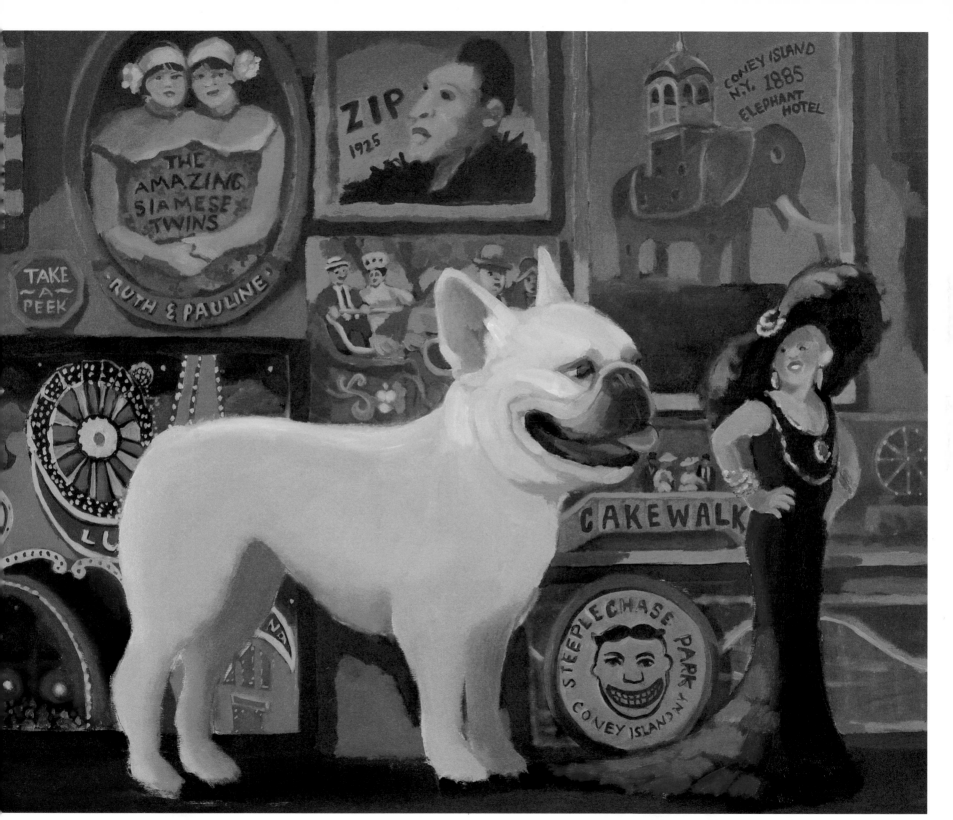

An unruly phalanx,
a rowdy brigade,
was about to step off
with the Mermaid Parade.
Not one march by Sousa
no bagpipes — no kilt,
just land-lubbing sea nymphs
…is *that* Uncle Milt?

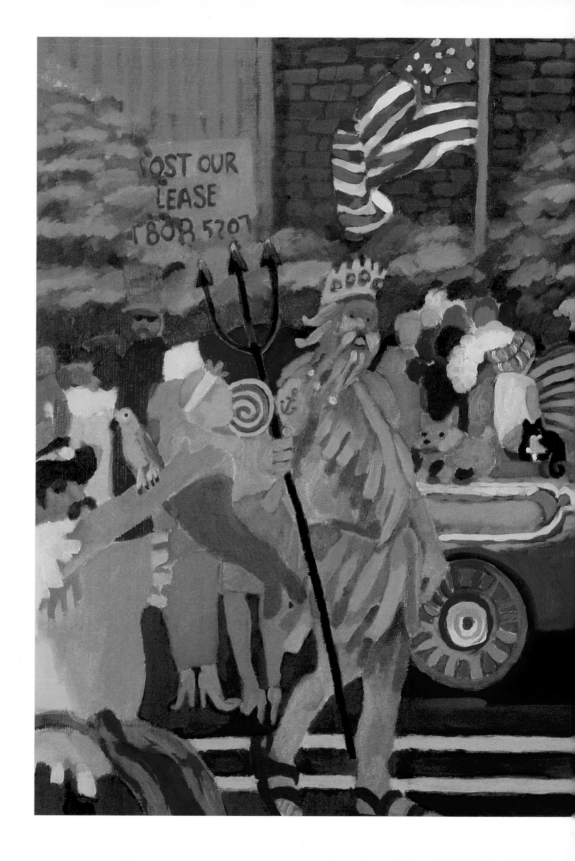

Play Ball! ricocheted
from the Cyclones' ballpark,
home to the team
with the coaster's trademark.
Sandy the Seagull
incited the fans.
They clapped when he flapped
while I worked a tan.

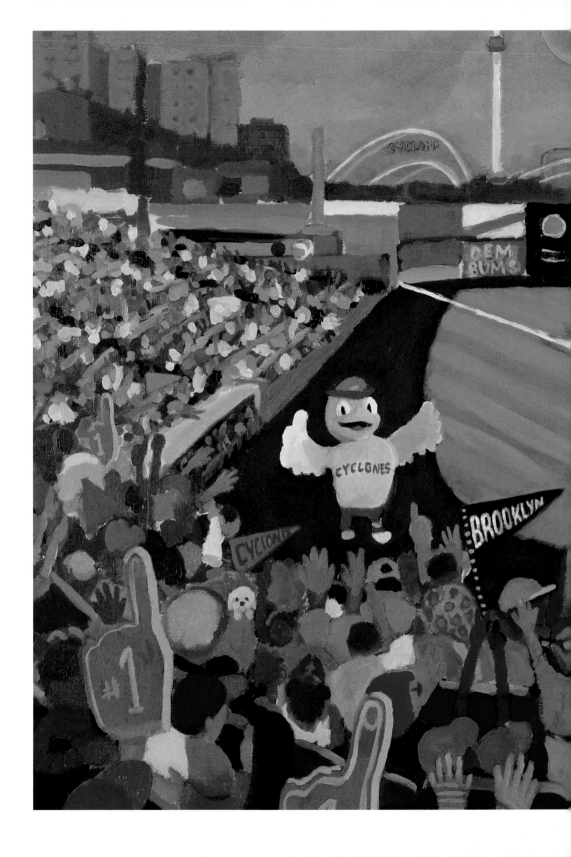

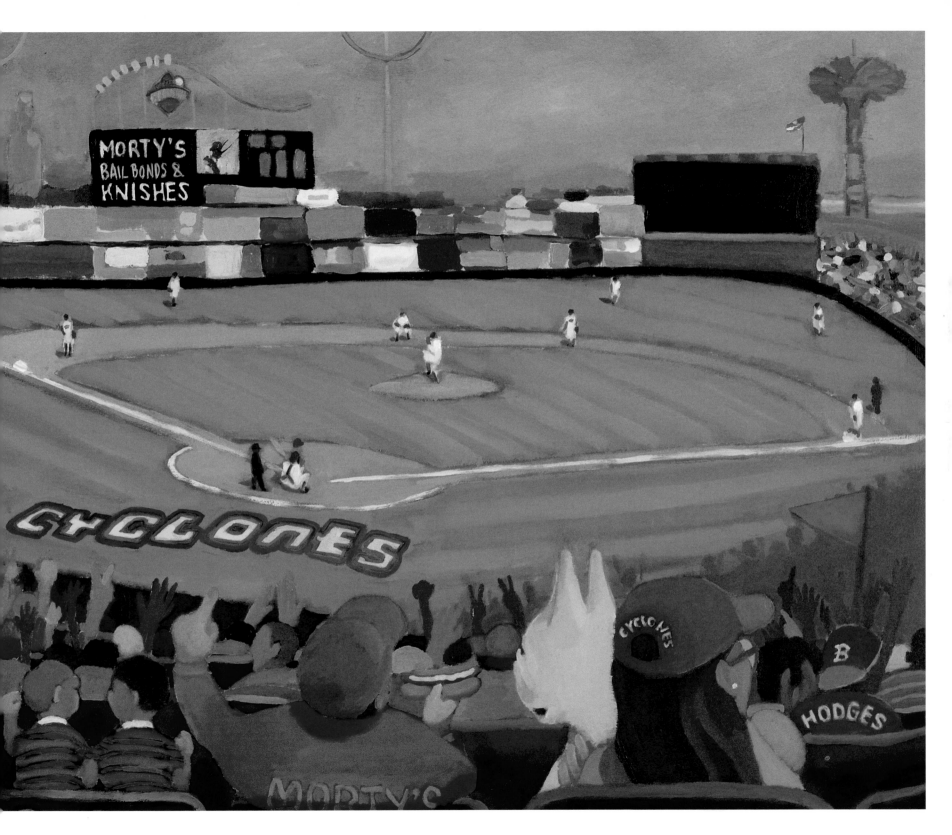

My friends at the dog run
would plotz if they knew,
I was standing in front of
a human tattoo.
Are those piercings or craters,
those holes in his lobes?
From two bands of rubber
swung four mighty globes.

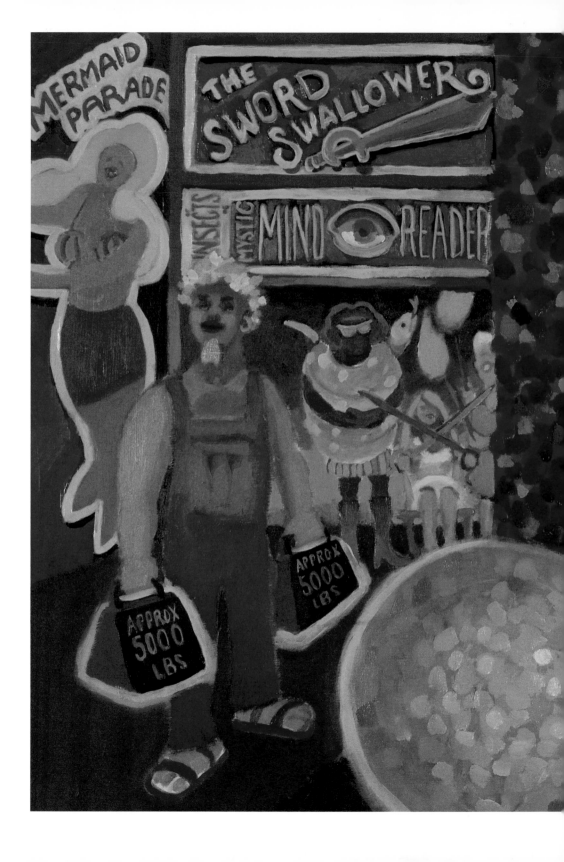

If Coney were a country
instead of a beach,
seen from the sky
she would be a pastiche
of people from places
like Peru and Peoria,
Patagonia, Poland
even far-off Astoria.

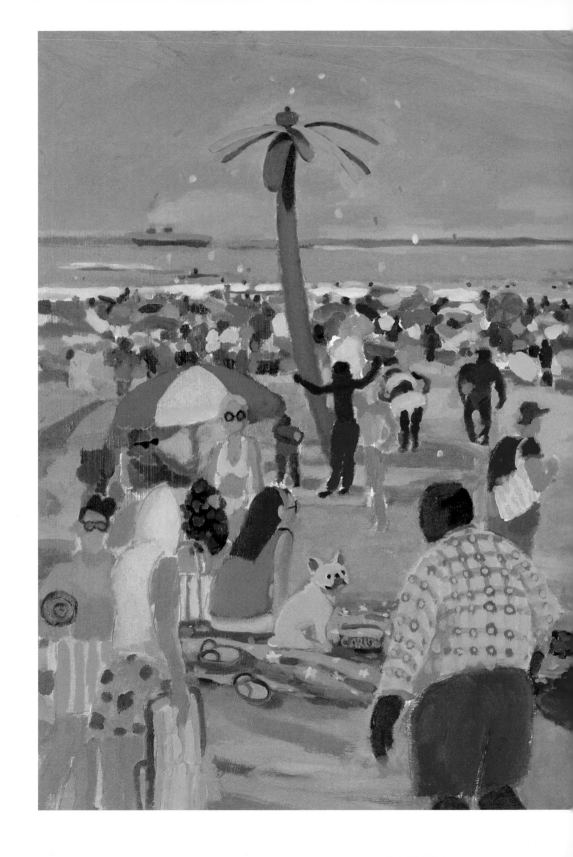

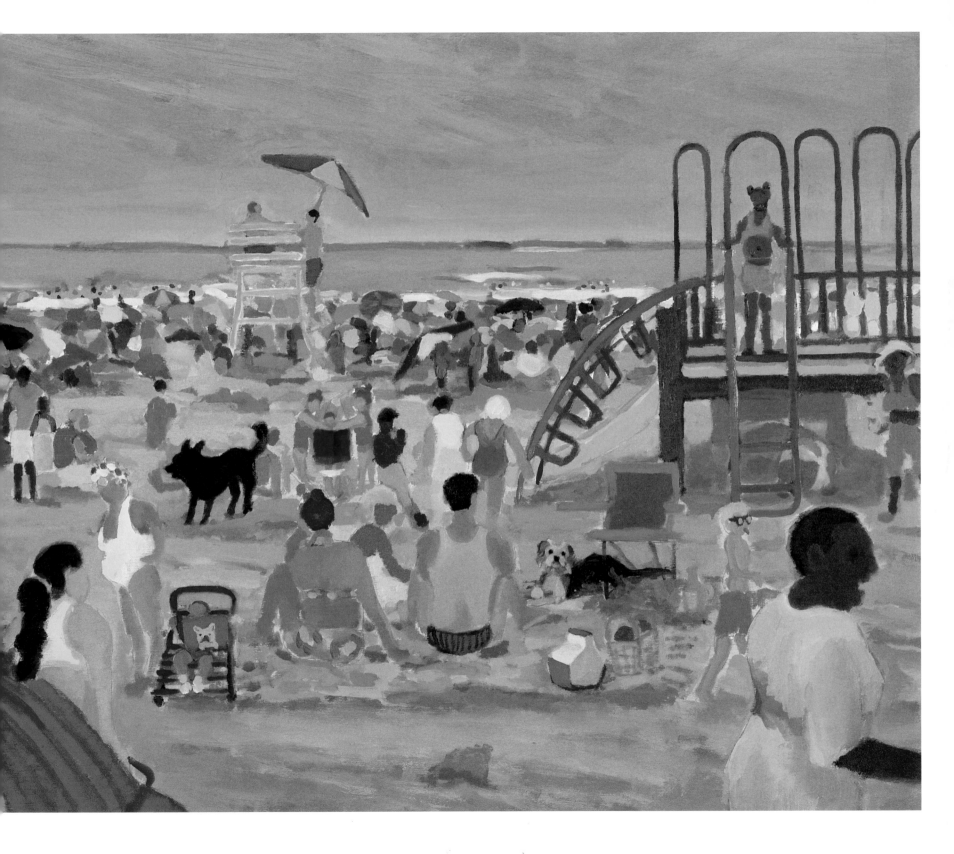

So have a great time
without breaking the bank,
a MetroCard swipe,
a few bucks for a frank.
If you need to escape
or you're seeking a thrill,
the time will fly by
where they say it stands still.

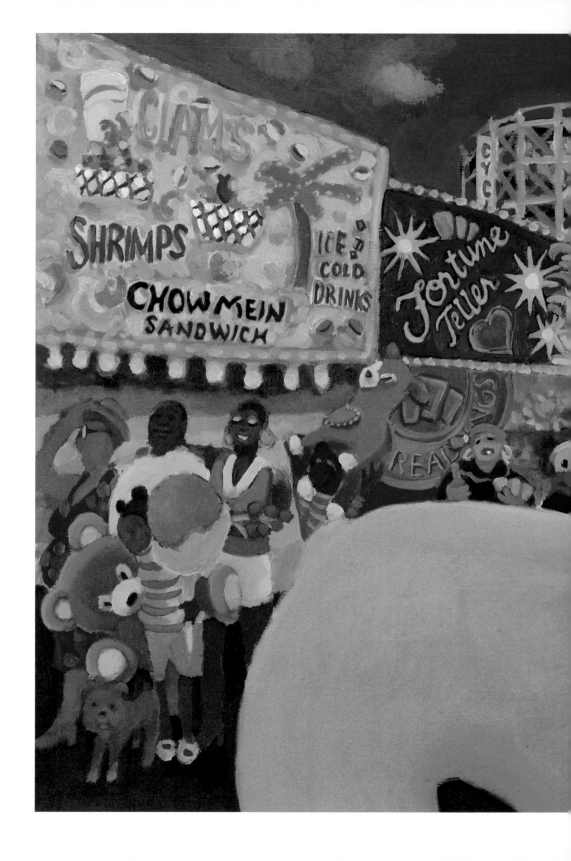

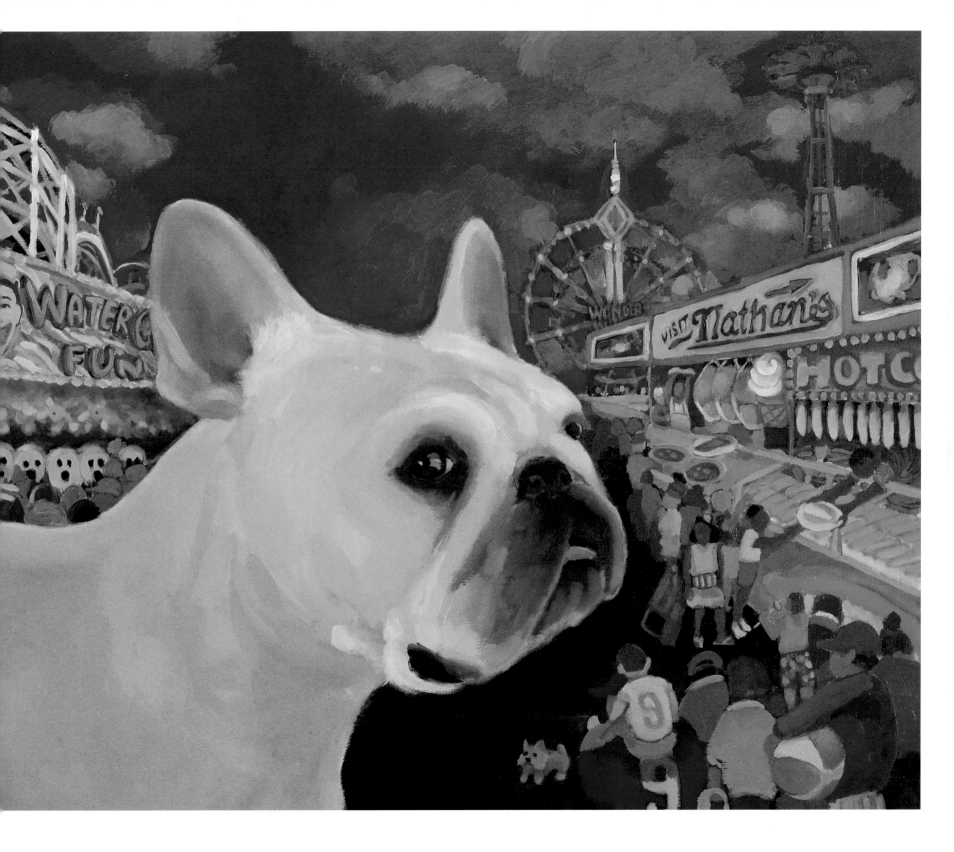

When I get a toy that's all fluffy and new

I sniff it, I shake it and give it a chew

But the toy I most treasure is scruffy and old

and just like dear Coney, to me it's pure gold

The End

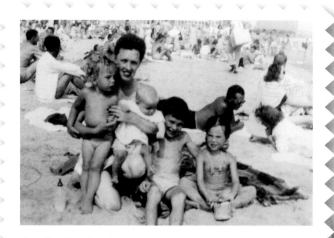

The Naughten family at the beach, 1947

Sean, Maureen, Kevin and Bernadette Naughten pretending to fish, 1949

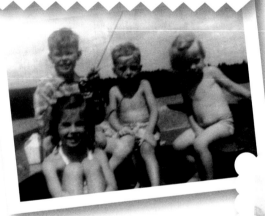

Left and below: Alison's grandmother Sophie with friends at Coney Island, 1931

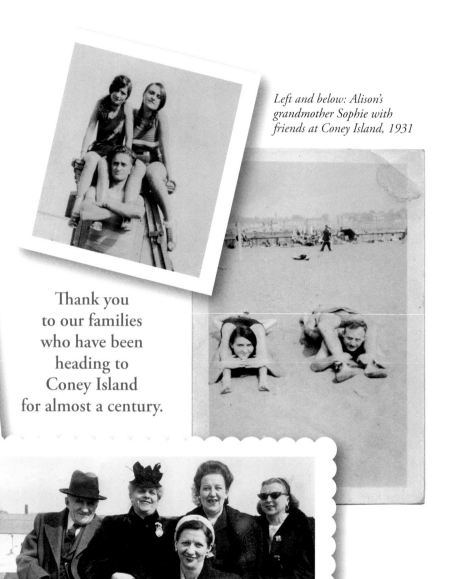

Thank you to our families who have been heading to Coney Island for almost a century.

Special thanks to:

The Metropolitan Transportation Authority
Cyclone Coasters, Inc.
Nathan's Famous
The New York Aquarium
Deno's Wonder Wheel
Brooklyn Cyclones
The Coney Island Museum
Coney Island USA and The Mermaid Parade

HOW SWEET YOU ARE!

Alison's great grandfather Ben, great aunts, and mother, Leah (at age six) at Steeplechase Pier, 1945